The Brown Dog
and
His Memorial

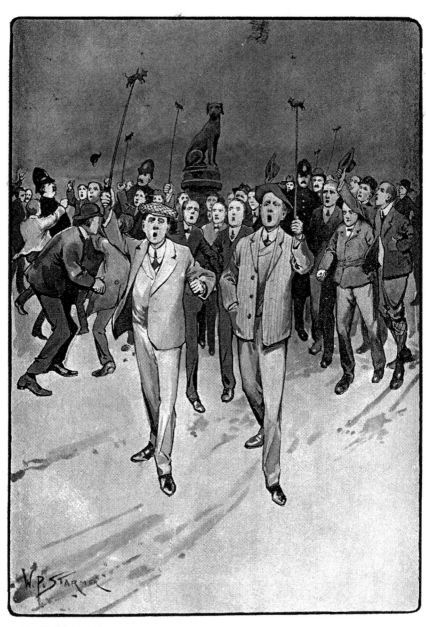

STUDENTS ROUND - - -
BROWN DOG MEMORIAL.

THE BROWN DOG

AND

HIS MEMORIAL

BY

EDWARD K. FORD

Facsimile edition
Euston Grove Press
2013

Euston Grove Press
20 Elderwood Place
London SE27 0HL UK
www.eustongrove.com

Ford, Edward K.
1908
The Brown Dog and His Memorial

This facsimile edition published in 2013
by Euston Grove Press
ISBN: 978-1-906267-34-6 (paperback)
ISBN: 978-1-906267-33-9 (e-book)

First published in 1908
by Miss Lind-Af-Hageby's Anti-Vivisection Council, London
OCLC Number 67048415
The source used for this facsimile has a label glued over the
publisher's name, replacing it with:
"The Animal Defence and Anti-Vivisection Society
15, St James's Place, London, S.W. 1"

British Library Cataloguing in Publication Data

A catalogue record for this book is available from the British Library.

Table of Contents

The brown dog and his memorial ...1

Crackers used ...15

Miss Hageby howled down ...15

Girls help the students ...16

"The brown dog"...20

The Morning Leader..36

The Times ...37

The Daily News..38

Daily News thanked...38

An apology ...39

The Brown Dog of Battersea. A Cynical Ballad (song)40

There's Life in the Brown Dog yet (poem)48

ALKING in the Strand one evening towards the end of 1907, I was suddenly surrounded by a number of excited young men, who shouted, "*Down with the Brown Dog!*" and, after having had my nose brushed with a fluffy toy animal, carried aloft by one of the youths, I naturally inquired the cause of this unusual attention to peaceful pedestrians. By way of an answer I was swept along the pavement and tightly enclosed in the midst of what was apparently a party of medical students, inspired by a common grievance, and intent on airing it to the whole world. Trying to make myself heard above the din, I ventured upon another question, which, however, was speedily drowned in the militant tones of a war song, of which I caught the following words:

> As we go walking after dark,
> We turn our steps to Latchmere Park,
> And there we see, to our surprise,
> A little brown dog that stands and lies.
>
>> Ha, ha, ha! Hee, hee, hee!
>> Little brown dog how we hate thee.
>> Ha, ha, ha! Hee, hee, hee!
>> Little brown dog how we hate thee.
>
> If we had a dog which told such fibs
> We'd ply a whip about his ribs;
> To tan him well we would nòt fail,
> For carrying such a monstrous tale.
>
>> Ha, ha, ha! Hee, hee, hee, etc.
>
> Little brown dogs may sit and beg,
> But they must not pull the public's leg,
> And if put-up stories shock the town,
> The authorities ought to pull them down.
>
>> Ha, ha, ha! Hee, hee, hee!
>> Little brown dog how we hate thee.
>> Ha, ha, ha! You and we,
>> And you shall see what you shall see!

4

Having at last extricated myself from the little knot of demonstrating medicos, and being greatly puzzled over the identity of the " brown dog," whose musical condemnation had been set to the tune of the " Little Brown Jug," I crossed the street to lay my awakened curiosity before the undoubtedly superior knowledge of a smiling constable. My expectations were not disappointed, for pointing to the students he said :

" It's only them brown doggers, sir. They's riled because their professor did something to a dawg wot's called vivispection, and the ladies, they stuck up a monument to the dawg in Battersea, and they says it was tortured, and that the professor he broke the law, but them young gentlemen says it's a shame and now the fat's in the fire, sir."

" And what do you think will happen? Will the ladies or the students get the best of it? "

" Well, sir, I'm thinking the ladies will, for that vivispection seems to me an ugly business, and if the young gents smash up the dawg as they are tryin', I reckon the ladies 'll pretty soon stick it up again."

With a wink of the eye he passed on and left me musing where I stood. Vivisection—I had often heard of that scientific necessity, and of what seemed to me a somewhat misguided enthusiasm on the part of those who wished to curtail what was but a legitimate method of research. Some years ago I had had a lengthy conversation on the subject with a medical man engaged in experiments upon live animals, and he had assured me that the pain inflicted was infinitesimal, and that the practice was strictly controlled in this country by a law which made any cruelty to animals impossible. The idea of raising a monument to one of the " vivispection dawgs " seemed to me strangely incongruous in view of the facts which had been placed before me. But not being strongly prejudiced on either side, and unable to free myself from a growing interest in the controversy of which I had so unexpectedly caught a glimpse, I determined to make myself thoroughly acquainted with the circumstances which underlay it.

It was a fine evening, and having my time at my disposal, I boarded a 'bus and proceeded in the direction of Battersea. Why not pay a visit to this canine shrine of sentiment, and learn something more of its idol? Having arrived in Battersea, inquiries soon brought me to the vicinity of the Latchmere Recreation Ground, where, addressing a wide-awake-

looking lad of ten, I asked him to show me the spot where stood the monument to a dog. His eyes brightened.

" Our dorg, sir ; I should think I know. I helped to fight the stoodents, and if they're comin' again we'll give'em wot for."

" But why are you so interested in that dog ? " I asked, as we turned down a side street.

" Oh, I should think I am. · I wouldn't 'ave my Bill cut open alive an' kept in a cage for two months and 'anded over from one cutter to another, no, not if I knows it; and as for them stuck-up chaps who yell and shriek 'cause they wants more hanimals to cut up, dad said last night he'd sooner die in peace than have them doctorin' 'im."

" But, my dear boy, when your father is ill I am sure he is glad enough to be helped by doctors ? "

" Not by them doctors, though. We don't trust them 'ere in Battersea. We've got an 'orspital of our own, where the doctors don't believe in cutting hanimals up alive , it's called the Anti-Vivisection 'Orspital, and we always goes there when we're ill, mother and dad and Nellie and me."

I had evidently been landed in a hotbed of anti-vivisection, where the very boys in the street take up cudgels for the dogs. I have many times come across little boys who throw stones at dogs, but the companionship of the Battersea Brown Dog seemed to have produced a solicitousness for animal welfare, only too often absent from the heart of thoughtless boyhood.

" 'Ere 'e is," said my little guide in a proud voice.

Perched on a granite pillar I saw before me the bronze form of an innocent-looking terrier, whose mild countenance and sleek head bore no trace of the martyr's crown with which his fame had been invested. The monument on the whole had a pleasing appearance, and was likely to endear itself to a thirsty world by providing a fountain with drinking water for men and dogs. Did the givers of this monument have a subtle symbology at the back of their heads, not divined by the trusting borough councillors who accepted their gift? Did they mean to anathematise vivisection by leading " humans " and " canines " peacefully and unitedly to the waters of life—the outpouring of love and charity—among which the vivisector's

knife would—in their view—sadly rust? Be that as it may, their belief is unmistakably set down in the following inscription :

In Memory of the Brown Terrier
Dog Done to Death in the Laboratories
of University College in February,
1903, after having endured Vivisection
extending over more than Two Months
and having been handed over from
one Vivisector to Another
Till Death came to his Release.

"Also in Memory of the 232 dogs Vivisected at the same place during the year 1902. Men and women of England, how long shall these Things be? "

This inscription certainly explained my little Battersea friend's animosity against vivisecting doctors, but whether the inscription was true or false was a matter whereupon I could pronounce no judgment. I found the monument guarded by two stalwart policemen, who were not unsympathetic to their unusual protégé, but who could give me no detailed information of the kind I wanted. Having been absent from England for a number of years, I knew nothing of the Brown Dog beyond what I had gathered that evening.

The following day I procured a number of newspapers which gave accounts of the Brown Dog events since the beginning of the students' riots ; I also obtained first-hand information from various sources.

The Brown Dog Memorial, having been presented to the Battersea Borough Council by a body of anti-vivisectionists who had raised the necessary funds by public subscription, was unveiled by the Mayor of Battersea on September 15th, 1906. For a little over a year it remained unmolested, though there had been some talk of a dangerous reckoning with the outraged feelings of University College, incarnate in its medical students. In the early autumn of 1907 a successful carnival in aid of the Anti-Vivisection Hospital helped once more to focus attention on Battersea and its anti-vivisection precept and practice. The little cold bronze figure of the pet which Battersea had taken to heart had a peculiarly heating effect on the

imagination of the rising generation whose mental feeding is entrusted to the teaching vivisectors of London.

On November 20th a number of students from University College and Middlesex Hospital attempted to wreck the Brown Dog Memorial. One used a sledgehammer, and one tried to wrench away the legs of the dog. Ten were arrested, and were the following day fined £5 each by Mr. Paul Taylor, at the South-West London Police Court. The magistrate said that the erection of the memorial was legitimate, and asked the students to remember that there was another side to the question than the one which they regarded as personal to themselves. He warned them that if such conduct were repeated the offending persons would have to go to prison without the option of a fine. The occasion was celebrated by a bonfire at University College. On November 22nd students from King's College, Guy's, and Middlesex Hospitals joined the University College students, amid cries of "Good old Starling," and "Down with the Brown Dog," in a procession at the head of which was carried a " hideous " and " life-size " effigy of Mr. Paul Taylor. Singing :

> " Let's hang Paul Taylor on a sour apple tree
> As we go marching on "

the crowd of students and idlers, which was about a thousand strong, and which the police, being unprepared, were unable to stop, proceeded along the Strand to King's College. Here vivisectional ardour and contempt of law and order ruled that the " guy " should be severely punished. It was accordingly fixed against the iron railings in the centre of the yard and a light applied to the right arm amidst loud shouts of " Down with Paul Taylor, the unjust judge." According to the *Standard* " the guy refused to burn, and the students left the College as suddenly as they had come, making their way by the Embankment to the river where the remains were solemnly committed to the water amid hisses and groans. From there they marched to Guy's and then returned to the University where they found a large detachment of police, four hundred strong, ready to receive them, drawn up by the railings of the College. . . Outside the College there was a demonstration for a few minutes, cheers in honour of the College and of Professor Starling, and groans and hisses for Mr. Paul Taylor."

On November 25th there was another and unsuccessful demonstration against Mr. Paul Taylor of some 150 students which led to the arrest of five. Three medical students were also charged at Marlborough Street

with having used "insulting words and behaviour, whereby a breach of the peace might have been occasioned" in Piccadilly Circus at midnight on the previous Saturday, and each was ordered to enter into his own recognisances in the sum of £5 to keep the peace for six months. On the same day there was a meeting of students at University College at which the Provost, Dr. Gregory Foster, presided. The object of the meeting was to appoint a committee of students to defray the cost of the damage done at the Brown Dog bonfire some days previously. Whilst the Provost is reported as having expressed regret at the bonfire being held, and especially at the loss of the ancient College wheelbarrow, it seemed strange that no words of condemnation of the behaviour of the students should have fallen from his lips.

On November 30th three young veterinary students were charged before Sir A. de Rutzen, at Bow Street, with being guilty of insulting behaviour, and of being drunk and disorderly in Leicester Square. There had been about 100 students engaged in a midnight demonstration against the Brown Dog, and one of them had struck two persons in the face with " a large, ill-shaped model " of a brown dog, which was produced in Court for the magistrate's inspection. It was explained that the defendants had come from a farewell college dinner, given to one of their professors, at which the stuffed dog, the brown skin of which had evidently been supplied by an Irish terrier, had figured. The magistrate expressed regret that three respectable-looking men should have behaved in such a foolish way, and dealt leniently with the offenders.

By December 5th the pro-vivisectional feeling had become alarmingly uncontrollable and unreasonable, for a band of about 100 medical students from King's College and St. Mary's Hospital invaded a meeting held at the Paddington Baths in favour of Women's Suffrage, under the presidency of Mrs. Henry Fawcett, and enacted scenes of ruffianism which in no way could enlist sympathy with their object or confidence in their judgment of the ethics of vivisection. Mrs. Fawcett appealed in vain to their sense of honour.

"I appeal to you as gentlemen," she said, "to give some attention to the meeting, and not to disturb its proceedings." This was answered by a " crescendo of disorder " which ended by a fight, during which the meeting was completely broken up, water jugs, chairs, and tables smashed, and one steward had his ear badly torn. The *Daily Express* headed its

report of the proceedings with "Medical Students' Gallant Fight with Women," and related how, "in the centre of the hall, when a particularly fierce struggle was going on, a woman pluckily rushed in, heedless of the blows—several of which reached her—and separated the combatants."

Why the women's cause should be identified with that of anti-vivisection seemed to me at the time to be somewhat inexplicable, but I have since learnt that women were prominent among the pioneers of the movement against vivisection, such as the late Dr. Anna Kingsford, Miss Frances Power Cobbe, the Princess Eugenie of Sweden, and others, some of whom were also ardent upholders of the social and political enfranchisement of women. And at the present moment it seems to me that the greater proportion of those who wholeheartedly and without remuneration give their services to the cause of anti-vivisection are women. There is, therefore, every reason to anticipate that political freedom for women will mean moral and legal restraint for vivisectors.

The papers having announced in more or less agitated terms that the students had planned a great demonstration and another raid on the Brown Dog on December 10th, I determined to be present and to study the character of the objectors. "In their agitation against the 'Brown Dog' statue at Battersea," wrote one journal, "the inscription on which they consider offensive, the students of London University and the hospitals have enlisted the sympathies of the hundreds of Oxford and Cambridge undergraduates who are in town to-day for the 'Varsity Rugby football match. It is proposed to hold a great mass meeting of between 2,000 and 3,000 students and 'Varsity men at Trafalgar Square to-night, at about 11 p.m. The sole object of the meeting, it is stated, is to make a public protest against the inscription on the Brown Dog's statue, which is described as 'an insult to the London University and to the medical faculty generally.'" Notices also appeared in the Press relating that the students had petitioned Sir Philip Magnus to lay the question of the Brown Dog before Parliament, and that the member for the University of London had consented to do so. Reference was also made to the students' "firm determination" to cause the offending statue to be taken down and to continue the demonstrations until that object had been attained.

Trafalgar Square was well in the hands of the police in the afternoon of the demonstration. The crowds of excited onlookers, the pliable items

of unprincipled humanity, always ready to form the ingredients of an emotion-swayed mob, had been kept wisely " on the move " by the constables. The usual "souvenir" paper handkerchiefs, inseparable from jubilees, royal processions, or any remarkable display of agitational forces, whether constitutional or anarchistic, were sold by street vendors. I bought one, printed " in commemoration of the procession of students for the ' Square.' Another Brown Dog Demonstration, Tuesday, December 10th, 1907, at 11.30 p.m.," and asserting that the "Brown Dog's inscription is a lie, and the statuette an insult to the London University."

" Trafalgar Square for *All* " was the motto, and it struck me that the best way of settling the anti-vivisection agitation once and for ever would no doubt be for those who are engaged in animal experimentation to ask special police permission to send batches of the animals experimented upon in their laboratories to Trafalgar Square for a day's exhibition. Suspicion would naturally be allayed, and full confidence restored in the fate of brown dogs, and white and black,—cats, rabbits, horses, and monkeys—at the hands of these humane men of science, when the man in the street could see for himself that there were no painful wounds, or mutilations, or torturous diseases. I could not help wondering why this had not been done, and I decided to join the speechmakers under the column for the purpose of making this, as it seemed to me, very practical suggestion.

When the somewhat disordered procession of elated students arrived I speedily abandoned my idea. For these rowdy young men, headed by two youths bearing imitation brown dogs on poles, were evidently actuated by blind prejudice and the false *esprit de corps* which is alien alike to calm reason and a purely objective consideration of questions of morality. A feeling of uneasiness came over me as I watched the expressions on the faces of the young " haters " of the brown dog, and as I listened to their jokes. I am not a pedant, nor do I care for masculine youth clad in propriety and premature decorum. I have watched united studenticose expressions of feeling elsewhere; I have seen young men use fisticuffs in their clamour for the recognition of the rights of the oppressed; I have seen rough and material means used to achieve that which in its origin was fine and ideal. The light of *l'idéal éternel*, when it is there, shines through and through a plain face, or a common tongue, or even a heavy blow. But here I saw no such light, the power behind these crowds of riotous students lacked the signs which are inseparable from any movement springing from

the spiritually progressive instincts of humanity. There was an ugly
onslaught without the inspiration which makes ugly onslaughts beautiful.

The students had failed to obtain any serious support from the Oxford
and Cambridge undergraduates. Their procession had already been broken
up by the police in Kensington High Street. The disordered contingents
which reached Trafalgar Square lacked all cohesive strength, and in seek-
ing to mount the pedestal of the Nelson Column were easily out-man-
œuvred by the constables. An attempt at another " procession " was made
by a party of students who marched down Whitehall Place, headed by a
brown dog, soon to be scattered by mounted police. Small groups of stu-
dents now made rush upon rush for the would-be platform, and were hauled
down by the police, and after a struggle several were arrested. The diffi-
culty of keeping the growing crowd in order necessitated action from the
mounted police, who repeatedly rode in among the demonstrators and
their audience and dispersed them. I left the scene of demonstration, feel-
ing that I had gained a valuable personal acquaintance with the product
of the educational spirit of the vivisectional laboratories. For some hours
comparative quiet reigned in the Square, as many of the guardians of the
honour of vivisection had repaired to public-houses, restaurants, music-
halls and theatres to recuperate for new ventures. The Empire in Leices-
ter Square " was thronged with students, many of whom had to be removed
by the attendants," and there were rowdy scenes in Leicester Square and
Piccadilly when the theatres and public houses closed.

The evening's organised raid upon the Brown Dog monument had,
according to newspaper reports the following morning, ended somewhat
ignominiously.

" At Battersea the demonstrators met with a warm reception," wrote
the *Standard*. " Hostile crowds sided with the police, and attacked every-
one whom they imagined to be students. None of the demonstrators was
able to approach the statue, and at times it looked as if the disturbance
might assume a dangerous character." The arrangements for the seizure of
the Brown Dog had, according to the *Daily Mail*, been that " 300 secretly
selected students should descend upon Battersea at 4.25 and make a dash
for the statue, remove it with a crowbar, and carry it off, either to drop
it into the river or melt it down. Only about 100 turned up at dusk, and
these were driven back by a large body of police. The students sent out

scouts. To these only two constables were visible, the main body being in hiding in a shed in a corner of the ground.

" The police came out of their ambush and formed cordons across the path leading to the statue. Crowds of people had assembled around, and a slight attempt was made by the students to get at the statue, but so well guarded was it that no one got even close enough to throw a stone."

The *Daily Chronicle* reported that " some of the students formulated wildly incoherent protests and threats, but discreetly retired before the iron-shod front-hoofs of prancing horses into the shelter of neighbouring door-ways. From this retreat they were in turn driven into the middle of the road by the mounted men, and then unceremoniously pushed to the end of the thoroughfare and out into Battersea Park Road. Apparently they had had enough, and, finding themselves hemmed in on the one side by hostile anti-vivisectors and on the other by police, decided to make for their homes. On the way there was some disposition to make an attack on the Anti-Vivi-section Hospital, and this found vent in a few groans and hootings. The police had made preparations here also, and had anything further been attempted there would have been a warm reception for the ' raggers.' There was a series of minor skirmishes, but the police declined to arrest, and the report that ten men were at the police station was denied. A student who fell or threw himself from the top of a tram was only slightly injured, and the crowd refusing him a passage to the Hospital, he was taken to a neighbouring surgery, the people shouting, ' That's the Brown Dog's revenge ! ' ' "

The cry of police brutality was raised by sympathisers with the students and by the pro-vivisectionistic press. It was alleged that the police had used unnecessary force and hustled not only students but peaceful bystanders about in an objectionable way. Indignation was also expressed with the action of the police in not permitting the students to hold their meeting in Trafalgar Square.

Though in the repeated encounters between five o'clock and midnight there was certainly a good deal of force used on both sides, the policemen on duty on the whole behaved in an admirably good-humoured way, and with due regard to the license generally allowed to the boisterous spirits of students. No meeting can be allowed in Trafalgar Square without due notice being given to the Commissioner of Police, and as no such notice

had been given the police were clearly within their right in not regarding the attempted meeting as lawful.

The following is part of the report of the police court proceedings which appeared in the *Times* of December 12th:

At Bow-street, yesterday, Mr. Marsham had before him a number of charges arising out of disorderly scenes at a meeting of medical students in Trafalgar-square to protest against the "Brown Dog" memorial erected at Battersea by the Anti-Vivisection Society. There were twelve defendants, their names being Robert Sidney Overton, 21, Llewellyn Rhys Warburton, 20, Christopher Dudgeon, 20, Sidney Hampton White, 19, George Carr, 18, Arthur Keyworth, 24, Henry Leatham Burdett, 20, Sydney Norman Whitehead, 17, Frederick Simpson, 23, Alexander Bowley, 20, Frederick Herbert Grange, 23, and Henry Reginald Coombes, 30. Simpson was charged with attempting to rescue a prisoner from custody, and the other men were all charged with disorderly conduct and with resisting the police.

Mr. Muskett, who appeared for the Commissioner of Police, said that it would be convenient if the cases were taken in four batches. Dealing first with the charges against Overton and Warburton, he said that the police authorities were becoming weary of the scenes of turbulent disorder which were arising out of the "Brown Dog" memorial agitation. In the last case of the kind dealt with at this Court the offenders were, at his suggestion, dealt with in a very lenient manner, but he was now coming to the conclusion that such leniency was misplaced, for similar scenes of disorder were now taking place with some degree of regularity. They culminated in a very serious state of affairs on Tuesday in Trafalgar-square. Twelve arrests were made, and, as the cases varied in gravity, it would be necessary to take the evidence in each case.

Inspector Jarvis, of the A Division, was then called, and explained that meetings in Trafalgar-square were allowed to take place only on Saturday afternoons and Sundays, and then only with a permit to be obtained from the Commissioner of Police by giving four days' notice. At about a quarter to five on Tuesday afternoon a large crowd of young men, mostly medical students, gathered in the square. They were particularly noisy, shouting out "Brown Dog! Hurrah!" and the reserves from Scotland-yard had to be called out. After a time the crowd was dispersed, but at a quarter to six it gathered again from various quarters, and there was further disorder. At one time there were about 400 people in the square. Matters calmed down somewhat after a time, but at midnight there was a further rush which necessitated the calling out of the reserves again. The state of affairs was such that the special policemen, of whom there were between 200 and 300, could not be dismissed until two o'clock in the morning. The two defendants were linked arm in arm and were unusually noisy. The witness cautioned them, but they would not desist, and they were taken into custody.

During the hearing of the evidence there was some slight applause by some young fellows at the rear, and the magistrate remarked that he would have the public turned

out if there was any interference with the business of the Court. Addressing the defendants, he said that it was utter folly for them to carry on in this way. Overton observed that they were protesting against the inscription on the " Brown Dog " memorial at Battersea, which, he said, was a libel against the University College Hospital. He and Warburton were each fined 40s.

The case against Dudgeon and Simpson was next taken. Police-constable 27 A R gave evidence that he heard Dudgeon, who was carrying a banner, call out, " Who was the unjust judge ? " and the crowd at once shouted, " Paul Taylor." The witness received a blow on the back of his head by an umbrella or stick which knocked his helmet off, but he was not hurt. When Dudgeon was arrested he became violent and Simpson tried to release him from custody. The witness asked him to let go, and Simpson then " squared up " to him and struck him on the chest. The magistrate said he did not think that Simpson really intended to assault the constable, but both the defendants were to a certain extent violent and resisted the police. He fined them each £3.

White, Keyworth, Whitehead, Burdett, and Carr were next placed in the dock. It was alleged against Whitehead that he waved his arms, shouting " Brown Dog ! Hurrah ! " and on being spoken to by a constable he pushed the officer on one side. He had with him a packet of Chinese crackers, but had not let any off. Keyworth, it was stated, pressed in a disorderly manner round a policeman who had a man in custody, and Carr was plunging among the crowd " breaking out " right and left and shouting "Come on ! " White was waving a stick, and he and Burdett were also shouting. When White was taken into custody someone shouted, "Can't we release him ? " and he then began to struggle, but afterwards went quietly to the station. During the struggle he and his captor had a narrow escape from falling under a passing motor omnibus. White gave evidence on his own behalf. He said that he was a science student at King's College, and had nothing to do with the medical faculty. He was not a demonstrator, but happened to be passing by Trafalgar-square at the time of the meeting. He saw the police roughly handling the crowd, and he took the number of one constable, who at once arrested him. He did not remember having shouted. White was bound over in £5 to be of good behaviour for three months, and the other four defendants were each fined 40s. . . .

On December 12th the Press did not only contain lengthy reports of the police court proceedings consequent upon the Trafalgar Square demonstration, but also accounts of a new outbreak, of which the *Daily News* gave the following description :

Over 200 strong, the " Brown Dog " students attended an anti-vivisection meeting at the Central Hall, Acton, last night, created wild disorder, and completely wrecked the meeting. Continued interruption resulted in a general free fight ; sticks were used, blows exchanged, and dozens of chairs and seats were smashed. Quiet was not restored until the police were summoned, and even then the fight continued for some time. One arrest was made, but bail was eventually allowed.

The meeting was held under the auspices of the Ealing and Acton Anti-Vivisection Society. Admission was by ticket, but the students had managed to obtain entry. Long before the commencement of the meeting they had taken possession of nearly the whole of the left side of the hall. When the chairman, Mr. H. S. Schultess Young, and speakers appeared on the platform they were greeted with loud shouts from the students, who let off crackers and waved hats and sticks.

CRACKERS USED.

Cries of " Rotter " and " Sit down " greeted the chairman's opening statement that he was entirely in sympathy with the conveners of the meeting. A little by-play with a number of kippers by one of the students first drew the serious attention of the stewards. They were forced back by the rather powerful odours of a large quantity of chemical matter distributed by the students. Quiet was temporarily restored, and the chairman appealed for fair play.

But crackers soon became prominent again, and when the Chairman asked for them to be put away, the students retorted with cries of " Put away the Brown Dog, then," and veiled references to an " antiquated mushroom."

When the first speaker, Miss Lind-af-Hageby, rose to address the meeting, several of the students stood on the chairs, and, amidst great uproar, endeavoured to put questions to the chairman. More quantities of the pungent chemical were thrown about the hall, and in various parts stewards were busily engaged during the next few moments in removing the small boxes which held the offending articles. The stench was so horrible that those in the centre of the hall were forced to move to the front and back, and during the remainder of the meeting the centre was quite deserted. All the ladies and many gentlemen held handkerchiefs to their faces, and many had to leave the hall. More than one was taken ill.

MISS HAGEBY HOWLED DOWN.

During all this time Miss Hageby was endeavouring to make herself heard above the uproar, but her remarks were greeted with cries of " Bosh ! " and the singing of the war song, " The Little Brown Dog." Excited arguments between students and stewards were at the same time in progress. Students blew kisses to the speaker, who con-tinued bravely in her endeavour to speak, but only a faint voice could be heard above the din. To the remark that anti-vivisectionists were actuated only by the best of humane motives a loud voice was heard to reply, " Ignorant busybodies, that's what you are," and " Have you ever been in a laboratory ? "

Finding it impossible to continue with any success, Miss Hageby resumed her seat. For quite five minutes there was great uproar, and eventually one of the students who had been persistent in appeals to the chairman was invited to the plat-form. He responded amid loud cheering, cat-calls, and further distribution of chemicals.

He faced the audience to the accompaniment of trumpet blasts and the rattling of crackers Quiet was resumed for their champion's declaration.

" It is not so much anti-vivisection we are protesting against," he declared, " but the intolerable nuisance of the ' Brown Dog.' That statue is an absolute and down-right libel upon us. Unfortunately there is no legal means at the present moment of obtaining redress. What we want and insist is that that should be taken down."

Cheering and further uproar followed. The horrible smell from chemicals was becoming quite unbearable, and a move was made in a body from the points most affected. The chairman remarked upon the "very remarkable odour" prevalent, and an indescribable uproar broke out. Stewards had lost all patience; heated and angry altercations resulted in an attempt to throw out one who appeared to be the ring-leader of the students.

GIRLS HELP THE STUDENTS.

This was the signal for concerted action. " Rescue!" "Rescue!" were the cries that rang through the hall, and immediately the students moved in a body towards their comrade. Hanging on to the ringleader were three stewards, and the students endeavoured to release their colleague. Then the male members of the audience joined in, and a general free fight was quickly in progress. Even a number of young girls, evidently friends of the students, did their best to beat off the official attack. The noise was deafening, but above the din could be heard at intervals the "rescue" cry from various parts of the hall, where it was evident the students' party were badly beset. Then for a time they got much the better of the fight.

Swaying backward and forward, the huge body of men and boys, stewards and students, fought for upwards of fifteen minutes. Chairs were being smashed and trampled underfoot, hats and clothing torn. Women shrieked, and matters were getting very serious. Fierce blows were being exchanged on either side, when the police suddenly made their appearance. Even their advent, however, did not mend matters for some moments, but gradually, one by one, the students were gripped and hauled out struggling and fighting.

The police, it must be said, acted with great caution and gentleness. Only one arrest was made, a student named Copman, from Westminster, being taken to the Uxbridge-road Station. The whole body of students accompanied him, and, after being charged, bailed him out. Then, with loud cries and waving of handkerchiefs, they charged down the main road and back to the hall. Here their re-entry was barred by the police. They were warned by the inspector that he would give them no other chance, and at this the students proceeded four abreast to the main road.

In one of the side streets a " road-up " barrier was stretched across the street. This, together with lamps, etc., was thrown down and trampled underfoot in the onward march of the students. Into the Uxbridge-road they marched. Many stalwart con-stables walked on either side. To the strains of the " Brown Dog " war song, about a mile was covered; then word went through the ranks that the police were to be outpaced. Off rushed the students, shouting and cheering, the policemen bravely endeavouring to keep pace. For another half mile the race continued. Then the gentlemen of the law resorted to strategy.

They were a little way behind the main body when an electric tram came along

They boarded this, and in a few moments caught up the van of the student army. Discovering the plot the latter attempted to stop the car by walking down the lines in front, but suddenly they left the track, and the car shot past triumphantly. This was what the students were evidently playing for, for when the car had gone some little distance down the road they pulled up, and with loud cheers doubled back on the road to Acton. The police, of course, had to follow. They then turned back again, and walked in fairly good order to Shepherd's Bush. Here they entered the Tube station, and left by train for various parts of the Metropolis.

The somewhat unrefined nature of the interruptions was further revealed in the report which appeared in the *Daily Chronicle*, from which I quote :

"The next speaker was Miss Lind-af-Hageby, the well-known anti-vivisectionist. Flourishing her hand, she struck a Ciceronian attitude, and asked what was the foundation of the society? "Hypocrisy," answered the 200 "catilines," one of whom was twirling a rattle. One of the students stood up and blew the lady a kiss. Boiling over with indignation, she drew herself up. "As I utter these words," she said, "I see a man blowing me kisses—" ("Shame!" from all the old ladies). The rest of Miss Lind-af-Hageby's indignation was lost in a beautiful "eggy" atmosphere that was now rolling heavily across the hall. "Change your socks!" shouted one of the students, and "Take your boots outside." Confusion was now reigning supreme. Here and there the stewards were remonstrating with the students, who began to sing :

> Ha, ha, ha! Hee, hee, hee!
> Little Brown Dog don't I love thee !

To repeat all the interruptions that were hurled at the speaker by the students would be to run the whole gamut of hospital slang, and Miss Lind-af-Hageby, still unbeaten, retired with great discretion."

The "Brown Dog" agitation had now taken complete hold of the public mind, and the British Press devoted columns and innumerable notices to the doings and intentions of the students. The broader questions at issue between the vivisectors and their critics were naturally raised, and all England became plunged in the seething and turbulent cross currents of the controversy. There was an abundance of satire and sneers aimed at the anti-vivisectionists.

In a leader of December 12th the *Morning Post* gave vent to a somewhat laboured facetiousness which, in its simulation of medical wit and psychological insight into the minds of reformers, bore a strong resemblance to the *anti*-anti-vivisection ebullitions which I have now had occasion to notice appear in the *British Medical Journal* with ill-tempered regu-

larity. After classifying anti-vivisection, anti-nicotine, and anti-vaccine bias, militant women suffrage tactics, and brown dog as forms of " floating conscience "—the analogy to floating kidney being lightly suggested—the *Morning Post* described the common symptoms of the disease to be a " sort of violent bias, sometimes accompanied by mild paroxysms." The bacteria of anti-vivisection were said to have saturated both the statue and its " disgusting inscription." Widespread, perhaps almost universal, sympathy with the indignation of the students over the insult offered to University College was announced, and astonishment was expressed that the anti-vivisectors should have been allowed to erect their monument " though the practice of vivisection, under proper restraint, is permitted by law and regarded by men of science, the only competent judges, as of the greatest use in the study of disease, and accompanied by less pain to the animals selected for operation than is caused to the innumerable living creatures that are every day killed for food."

In other journals those who had supported the erection of the memorial were told to " feel ashamed," and that they had hit " below the belt " ; the " unwarrantable libel " paraded against the fair fame of the students' alma mater was forcibly condemned, and the " peculiarly offensive " methods of anti-vivisection cranks and their soft-headed dupes were held up to obloquy.

Whilst generously referring to the Brown Dog as a " humble martyr," and acknowledging that vivisection is one of " those things which we would fain do without," the *Daily Mail* also devoted a leader to the injustice of the inscription, and in another article, headed " Home Office Powerless," published opinions expressed by Sir Philip Magnus, M.P., who was reported to have said : " I intend to bring the matter before Parliament. I discussed it with the Permanent Secretary at the Home Office, though I have not yet seen Mr. Gladstone. The secretary told me that the Home Office was powerless to interfere. The one thing that strikes me as somewhat peculiar is that policemen are specially detailed to guard this private monument. They are, of course, paid by the ratepayers, and the persons in authority, be they the County Council or the borough authorities, are practically endorsing the views of the people who gave the monument to Battersea. I do not think they have any right to take up this attitude."

The peculiar view of the duties of the police to which Sir Philip

Magnus had given expression must have been due to some temporary limitation of mental vision, caused by strong feeling, and not uncommon even in Parliamentarians. For are not the Metropolitan Police *always* specially detailed to guard, if not private monuments, private property? The private houses in Battersea as well as those near Hyde Park are every night entrusted to the vigilance of special policemen, and, though a man or his house may be extremely objectionable to his neighbours, attempts are not generally made to induce the police to leave him unprotected so that his property or life may be attacked without any attempt at hindrance from the guardians of public order. If a band of wild anti-vivisectionists attempted to break into the physiological laboratory of University College, smash up the instruments, liberate the animals, and thrash the vivisectors, there would be a public and legitimate demand for a sufficiently protective police force.

Though the rowdyism of the students and their ill-mannered demonstrations did not meet with the severe and public censure from the College authorities which—quite apart from the question of the Brown Dog monument—they would have merited, there arose, except in the camp of those strongly committed to the defence of vivisection, a general feeling of reprobation and suspiciousness towards vivisectional laboratories as educational institutions. Even supporters of vivisection showed distinct signs of alarm, and already, on November 23rd, the *Daily Graphic* had spoken of the students' demonstrations as "about as stupid and in as bad taste as could possibly be conceived," and added, with a kind of reproachful surprise: "One would have supposed that far from making the little brown dog an object of attack and ridicule, students with any respect for their profession would have regarded it as a humble creature that gave its life for the benefit of humanity, and would have treated its memory accordingly. But these are ideas which probably do not occur to the heroes of yesterday's exhibition." And the *Birmingham Daily Mail* (November 22nd) had despairingly asked: "Why is it that students cannot comport themselves in a manner befitting their station in life? They are drawn for the most part from a class which should ensure their having refined instincts, and in addition they obtain the benefit of a first-class education. . . . There is too great a tendency to look upon their offences as merely schoolboy larks. The latest students' escapade is one that will earn the reprobation of all good citizens."

The *Daily News* on December 11th voiced the views of a large section of the general public in the following leading article :—

"THE BROWN DOG."

Opponents as we are of vivisection we could wish for nothing better than that the medical students of London should continue the form of propaganda which they have recently adopted. The police-court records exhibit the mind of the demonstrators. Some were drunk ; others were delirious under the excitement of using rattles, a toy apparently adapted to their general mental development ; others, by their own account, were labouring under scientific enthusiasm. We can understand, though we do not share the standpoint of, a mature man of science, who, reluctantly, and regretfully, comes to the conclusion that he has the right to inflict suffering on animals, as seldom as possible and as mercifully as possible, in order to find the means of healing the suffering of men. There are doubtless some medical men whose attitude could be so described. But that is not the standpoint of these students. To them the whole question is a subject for mirth. They can parade as a toy and a scutcheon of which they are proud the effigy of that little brown dog, which was kept alive for two months on end to endure the worst torments which scientific ingenuity could devise. Neither pity nor regret nor the faintest sense of responsibility towards animals enters into their state of mind. These men, remember, will be the professors and the researchers of the future. The evidence before the Royal Commission has shown that there is really no independent non-professional check on vivisection in this country. It is the vivisectors themselves who control vivisection. We welcome these demonstrations, because we are sure that they will drive home to many who do not realise the character of the professional sentiment on this subject the need for fresh legislation and a totally different system of control.

Under the heading "Medical Hooligans," the *Star* wrote :—

We thank the students who yesterday organised another magnificent advertisement of the Brown Dog and the cause which it represents. They are doing more for the anti-vivisection movement than all the anti-vivisectionists have ever done, for they are making people think and talk about the hidden cruelties which are perpetrated in the name of scientific research. We sympathise with the police whose duty it is to control these young rowdies, and we congratulate them upon the tact and skill with which they did their duty. We also congratulate the Oxford and Cambridge men who were at Queen's Club yesterday, and who refused to accept the invitation of the medical larrikins to join in the riot. We are surprised, by the way, that the vivisectionist hierarchy has not severely discountenanced these vulgar displays which are doing so much harm to their cult. . . . But what excites the curiosity of the public most keenly is this problem : At what stage in his evolution does the medical hooligan become the humane scientist? The men who carried mocking effigies of the Brown Dog through London yesterday are the vivisectionists of to-morrow. . . .

My reflections upon encountering the students in Trafalgar-square, as well as the conflict of *ex parte* statements, had set me thinking seriously over the nature of vivisectional experiments and their influence upon those who uphold, practice, and witness it. In the hope of having my doubts set at rest I accordingly betook myself to the scientist whose acquaintance I had made a good many years previously, and whose opinions I had hitherto unhesitatingly accepted as correct. I told him that the mood and manners of the students had by no means impressed me favourably, and that I was surprised that the representatives of science at the London University had not taken active steps to suppress such methods, or to prove that the inscription was nothing but slander. He was in a state of evident mental irritation, and could only with difficulty speak calmly of the Brown Dog.

"My dear fellow," he said, "I am surprised that you can for one moment believe the statements by anti-vivisectionists, for that is clearly what has happened to you. The inscription on that infernal memorial is a deliberate, shameful falsehood, engraved in stone as a sole comfort to those who a few years ago in the Bayliss-Coleridge trial were punished for their insane zoölatry and libellous statements. The students are perfectly within their rights, and when they go to Acton or any other place and shout down one who is largely responsible for the dissemination of the ridiculous story of this noisy specimen of canine nuisances they do the best thing possible. I hope they will smash up the whole memorial, and I wish all these lying anti-vivisectionists were transported to a desert island where they could rave to their hearts' content."

After listening to a few more remarks in a similar strain I left my friend, as I found that this topic was far removed from the sedative influence of which he was undoubtedly in need. On returning home I bought a copy of the *Daily Mail* (December 13th), in which I read the following :—

As the result of a resolution passed by University College Committee, the college solicitors, Messrs. Pennington and Son, have been instructed to obtain the opinion of Mr. MacMorran, K.C., upon the whole facts of the Brown Dog Memorial at Battersea.

Dr. Gregory Foster, Provost of University College, said yesterday : "From my point of view it would be a great mistake for any official of University College to express any opinion at this stage. I would like to add that the best way to obtain good results is for the Press to continue to ventilate the true facts of the case, and then we may hope to reach some solution of the present difficulty."

Professor Starling, of the college, said: " All the statements that have been published by the faddists are entirely biassed and inaccurate. All sorts of wild accusations are made by innuendo, and the majority of the statements are absolutely inaccurate and absurd."

Mr. Runeckles, a member of the Battersea Borough Council, has given notice of the following motion :—

> *That as a matter of good sense and good taste and law and order, the un-English, libellous, and provocative inscription on the "Little Brown Dog" Memorial be removed.*

On the previous day the same journal had announced that the Senate of the London University was to deal with the question of legal redress and that Sir Philip Magnus intended to read to the Senate a letter containing the following resolution :— " That this meeting of students of every faculty of University College calls upon the Member of Parliament for the University to place their case before Parliament in regard to the slanderous and impudent inscription."

Here, then, three paths to the destruction of the memorial were to be entered upon : a libel action against the Battersea Borough Council was contemplated as a desideratum, and irrespective of the result of such preparations the students wished their " case " to be put before the wider tribunal of the British Parliament. Besides these two attacks from without the existence of the memorial was to be undermined from within by the motion of Mr. Runeckles in the assembly of those who had taken upon themselves the moral and legal responsibility of harbouring the Brown Dog and its inscription. Yet a fourth way was suggested by the Provost of University College, *i.e., the ventilation of the true facts of the case.*

" Slanderous," " impudent," " un-English," " libellous," and " provocative "—these were strong words to be used in deliberate and public statements. It was indeed time for me as well as for any other public-spirited man or woman to get into touch with the true facts. I procured copies of the Act of 1876 and of the evidence in the Bayliss v. Coleridge trial of 1903, and upon seeing the constant reference in the latter to the chapter " Fun " in the " Shambles of Science," I also obtained a copy of this book. In the anticipation that the evidence given before the Royal Commission on Vivisection of 1906 should throw further light on the Brown Dog, I bought copies of the first three volumes of evidence, and devoting all my spare time to the subject I settled down to

a prolonged and conscientious investigation of the fate of the Brown Dog.

A perusal of the Act speedily disillusioned me with regard to the restriction of vivisection in this country. For cannot a licensed British vivisector do just what he pleases? Can he not perform experiments without anæsthetics or treat one animal to a whole series of mutilations, provided he holds the necessary certificates and thinks fit to do so? The object of the vivisector is the fundamental consideration of the Act, and the suffering of the animals is merely a secondary consideration, and only subservient to the one deemed more important. I append an extract from the Act, the double-faced hypocrisy of which was never equalled in any legislative effort at compromise.

2. A person shall not perform on a living animal any experiment calculated to give pain, except subject to the restrictions imposed by this Act. Any person performing or taking part in performing any experiment calculated to give pain, in contravention of this Act, shall be guilty of an offence against this Act, and shall, if it be the first offence, be liable to a penalty not exceeding fifty pounds, and if it be the second or any subsequent offence, be liable, at the discretion of the court by which he is tried to a penalty not exceeding one hundred pounds or to imprisonment for a period not exceeding three months.

3. The following restrictions are imposed by this Act with respect to the performance on any living animal of an experiment calculated to give pain ; that is to say,

(1.) The experiment must be performed with a view to the advancement by new discovery of physiological knowledge or of knowledge which will be useful for saving or prolonging life or alleviating suffering ; and

(2.) The experiment must be performed by a person holding such license from one of Her Majesty's Principal Secretaries of State, in this Act referred to as the Secretary of State, as is in this Act mentioned, and in the case of a person holding such conditional license as is hereinafter mentioned, or of experiments performed for the purpose of instruction in a registered place ; and

(3.) The animal must during the whole of the experiment be under the influence of some anæsthetic of sufficient power to prevent the animal feeling pain ; and

(4.) The animal must, if the pain is likely to continue after the effect of the anæsthetic has ceased, or if any serious injury has been inflicted on the animal, be killed before it recovers from the influence of the anæsthetic which has been administered ; and

(5.) The experiment shall not be performed as an illustration of lectures in medical schools, hospitals, colleges, or elsewhere ; and

(6.) The experiment shall not be performed for the purpose of attaining manual skill.

Provided as follows; that is to say,

(1.) Experiments may be performed under the foregoing provisions as to the use of anæsthetics by a person giving illustrations of lectures in medical schools, hospitals, or colleges, or elsewhere, on such certificate being given, as in this Act mentioned, that the proposed experiments are absolutely necessary for the due instruction of the persons to whom such lectures are given with a view to their acquiring physiological knowledge or knowledge which will be useful to them for saving or prolonging life or alleviating suffering ; and

(2.) Experiments may be performed without anæsthetics on such certificate being given as in this Act mentioned, that insensibility cannot be produced without necessarily frustrating the objects of such experiments ; and

(3.) Experiments may be performed without the person who performed such experiments being under an obligation to cause the animal on which any such experiment is performed to be killed before it recovers from the influence of the anæsthetic on such certificate being given as in this Act mentioned, that the so killing the animal would necessarily frustrate the object of the experiment, and provided that the animal be killed as soon as such object has been attained ; and

(4.) Experiments may be performed not directly for the advancement by new discovery of physiological knowledge, or of knowledge which will be useful for saving or prolonging life or alleviating suffering, but for the purpose of testing a particular former discovery alleged to have been made for the advancement of such knowledge as last aforesaid, on such certificate being given as is in this Act mentioned, that such testing is absolutely necessary for the effectual advancement of such knowledge.

4. The substance known as urari or curare shall not for the purposes of this Act be deemed to be an anæsthetic.

5. Notwithstanding anything in this Act contained, an experiment calculated to give pain shall not be performed without anæsthetics on a dog or cat, except on such certificate being given as in this Act mentioned, stating in addition to the statements herein-before required to be made in such certificate, that for reasons specified in the certificate the object of the experiment will be necessarily frustrated unless it is performed on an animal similar in constitution and habits to a cat or dog, and no other animal is available for such experiment ; and an experiment calculated to give pain shall not be performed on any horse, ass, or mule except on such certificate being given as in this Act mentioned that the object of the experiment will be necessarily frustrated unless it is performed on a horse, ass, or mule, and that no other animal is available for such experiment.

6. Any exhibition to the general public, whether admitted on payment of money or gratuitously, of experiments on living animals calculated to give pain shall be illegal.

Any person performing or aiding in performing such experiments shall be deemed to be guilty of an offence against this Act, and shall, if it be the first offence, be liable to a penalty not exceeding fifty pounds, and if it be the second or any subsequent offence, be liable, at the discretion of the court by which he is tried, to a penalty not exceeding one hundred pounds or to imprisonment for a period not exceeding three months.

And any person publishing any notice of any such intended exhibition by advertisement in a newspaper, placard, or otherwise shall be liable to a penalty not exceeding one pound.

A person punished for an offence under this section shall not for the same offence be punishable under any other section of this Act.

11. Any application for a license under this Act and a certificate given as in this Act mentioned must be signed by one or more of the following persons ; that is to say : The President of the Royal Society, the President of the Royal Society of Edinburgh, the President of the Royal Irish Academy, the Presidents of the Royal Colleges of Surgeons in London, Edinburgh, or Dublin ; the Presidents of the Royal Colleges of Physicians in London, Edinburgh, or Dublin ; the President of the General Medical Council, the President of the Faculty of Physicians and Surgeons of Glasgow, the President of the Royal College of Veterinary Surgeons, or the President of the Royal Veterinary College, London, but in the case only of an experiment to be performed under anæsthetics with a view to the advancement by new discovery of veterinary science ;

And also (unless the applicant be a professor of physiology, medicine, anatomy, medical jurisprudence, materia medica, or surgery in a university in Great Britain or Ireland, or in University College, London, or in a college in Great Britain or Ireland incorporated by Royal Charter) by a professor of physiology, medicine, anatomy, medical jurisprudence, materia medica, or surgery in a university in Great Britain or Ireland, or in University College, London, or in a college in Great Britain or Ireland, incorporated by Royal Charter.

Provided that where any person applying for a certificate under this Act is himself one of the persons authorised to sign such certificate, the signature of some other of such persons shall be substituted for the signature of the applicant.

I had never sought to penetrate into the sentiments and injuries of laboratory dogs and cats, but it struck me that were I in their place I would rather be honestly cut up by a vivisector than maltreated under a system of red tape and sham humanity. A newspaper paragraph, referring to the effective administration of this Act by the Home Office and the annual Returns presented to the House of Commons by the Chief Inspector under the Act caused me to procure the Returns for the last five years.

If the reader of these Returns wishes to convince himself that everything is well with vivisection in this country he should endeavour to divest himself of what little commonsense nature may have endowed him with. For the stereotyped assurances of the absence of pain and of the law-abiding disposition of vivisectors do not carry conviction into the region of common sense. The outstanding fact that a very large percentage of the statutory recommenders under the Act *are themselves vivisectors*— and yet permitted to pronounce a judgment which cannot be unbiassed— should place the administration of this Act in the forefront of State-sanctioned absurdities. In the course of its first sittings the Royal Commission on Vivisection was informed by the Chief Inspector under the Act, Mr. Thane, that his annual Return is founded on the reports which vivisectors send to him of their own experiments. To the cognisance of this disquieting mode of procedure should also be added the fact that the *inspection* of experiments has been most inadequate. For over 400 licensed vivisectors there are only two inspectors, and these have not been able to give their whole time to the inspection. In 1903 they witnessed altogether thirty-six experiments, in 1904 thirty-four, in 1905 twenty-three. The number of tabulated experiments in England and Scotland during this triennial period was 89,581.

The " Brown Dog trial " took place in November, 1903. Miss Lind-af-Hageby and Miss Schartau had written a book entitled the " Shambles of Science," in which they gave their impressions and graphic descriptions of a series of vivisectional demonstrations before students in London. These demonstrations had taken place at the Physiological Laboratory of the University of London, at King's College, and at University College, and the authors of this book were permitted to attend them in their capacity of " partial students " at the London School of Medicine for Women. " They were regarded," said Professor Starling, in his evidence before the Royal Commission, " by the teacher of physiology at the Women's School as being very advanced and intelligent students, and there was no difficulty in recommending them to be admitted to the general lectures." (Q. 3,553.)

It would, therefore, seem that the vivisectors did not call in question their capacity for forming an intelligent opinion until they had been instrumental in making public details of a kind, which do not find their way in the annual Returns.

The chapter " Fun," which was quoted at length during the trial, and which the vivisectors received with such violent resentment, describes, with a sarcasm born of intense indignation, the behaviour of the students during the class-room vivisection of the Brown Dog. It was contended by the vivisectors that this account of the levity and heartless amusement of the students was grossly exaggerated or even maliciously invented. It is a pity that the vivisectors did not accompany their strong repudiation of the charge made with a warning to the students not to carry their vivisectional levity into the streets and market-places. For at the present moment few can doubt the truth of the accusation of levity. Have not the students of University College *continued* their amusement and their jokes over the Brown Dog in a manner which has completely destroyed all lingering faith in the dignified seriousness and solemnity of their vivisectional lessons?

A statement dealing with the same experiment was drawn up for Mr. Coleridge at his request by one of these ladies and read by him at an anti-vivisection meeting held at St. James's Hall in May, 1903. It caused Mr. Bayliss—the vivisector named—to bring an action for libel, and contained certain points which at the trial were not contradicted or traversed, whilst others were absolutely denied.

There was no contradiction of the statement than on February 2nd, 1903, the witness had seen an experiment by Dr. W. M. Bayliss at University College on a brown dog of the terrier type, which was stretched on its back on an operation board with its legs fixed and its head held in a holder.

It was admitted that whilst the neck had been opened for the demonstration experiment there was left in a fresh wound in the belly of the dog a pair of clamping forceps, and that the inference which the witness had drawn that this was not the first time that the dog had to serve science was correct.

It was admitted that the dog moved. It was admitted that the lecturer said nothing to the students about the administration of an anæsthetic. It was admitted that there was no smell of ether or chloroform in the room. It was acknowledged that there was no apparatus for anæsthetising the animal at work in the lecture-room.

It was denied that the movements of the dog were purposeful or indicated suffering. It was asserted that the dog was unconscious and

under the influence of an anæsthetic whilst in the lecture-room. The plaintiff's case was chiefly concerned with pressing this latter contention, and the jury gave a verdict for Dr. Bayliss, and assessed the damages at £2,000.

Leaving out anti-vivisectionists' allegations altogether, the following are the broad lines of the story of the Brown Dog, based on the evidence of Dr. Bayliss and Professor Starling.

The first vivisection of the animal took place on December 3rd, 1902. " Working " under Certificate B, Professor Starling opened the abdomen for the purpose of tying the pancreatic duct. He desired to see whether inflammation would be set up as a result of the abnormal condition thus induced. Deprived of the full use of its pancreas, the dog lived in a cage for a period of two months. In explanation of the complaint made of the sound of a long-drawn howling and whining, like that of dogs in terror and agony, Dr. Bayliss stated that " all dogs in confinement, especially when not taken out for any considerable length of time, will howl and whine." On February 2nd, 1903, Professor Starling subjected the animal to a second vivisection. For the purpose of studying the effect of the former operation he again opened its belly for an " experimental inspection," which, according to the evidence of Dr. Bayliss, lasted from half-an-hour to three-quarters of an hour. The experiment being completed and the object attained, Professor Starling clamped the wound with a pair of forceps and handed over the dog to Dr. Bayliss, who subjected it to a third and totally different vivisectional experiment. He made an opening in the front of the neck, exposing the duct of one of the salivary glands and the lingual nerve of the same side. Electrodes were placed on the divided nerve, tubes were tied into the carotid artery, and in the salivary duct. The dog was then carried into the lecture-room for the demonstration to students, described in the chapter " Fun " and referred to in the statement. The electrical stimulation of the exposed nerve not having brought about the desired result in half-an-hour—the failure being due, according to the evidence of Dr. Bayliss, to what Professor Starling called the " morbid " condition of the dog—the animal was taken out of the lecture-room by Scuffle, the laboratory attendant. It now passed into the hands of a third physiologist, an unlicensed research student, Mr. Dale, who told the Court that he was interested in the pancreas of the dog, and that he killed it by thrusting a knife into its heart. Scuffle, however,

stated on oath that he had seen Mr. Dale kill the dog by means of an anæsthetic. The divergence in the evidence of the two witnesses who were present at the last scene of this much-used animal's existence must have been rather discomforting to those who believe in the scrupulous accuracy of vivisectional observations and accounts.

The most important revelation contained in this description is the undoubted breach of the Act of 1876, and the disregard of the provisions under which Certificate B is granted, which the conduct of the two vivisectors implied. The Act clearly lays down (see page 24) that an animal which has been subjected to more than one operation is to be killed *as soon as the object of the experiment has been attained.* There are no qualifications, there is no bargaining with this simple condition which, to say the least, should be a reasonable restriction even for an ardent vivisector. He may legally use an animal for a whole series of vivisections under certificate B, but, having attained his object, he is *not* to hand the animal over for fresh mutilations and new quests at the hands of colleagues.

In this case the law was clearly disobeyed. In his evidence at the trial Professor Starling admitted (Q. 454) that his observation of the Brown Dog was completed after the second vivisection, thereby showing that his object had been attained. It would, therefore, have been his clear duty to kill the dog. But the strange methods prevalent at University College were exposed in the following manner by Mr. Bayliss in answer to Q. 144, etc.

" Now, supposing then, this dog had been operated upon by Professor Starling in December, had been examined in February, and the experiment had been completed, was there any statutory duty, according to your view of the law, to destroy it ?"

" So it was —— the dog was being destroyed, but the experiment was done on the dog during the process of its destruction."

" Then do I understand your view of the law to be this, that in the course of destroying a dog you may subject it to all kinds of further operations, because you say it will never recover consciousness before its death ?"

Answer : " Yes, certainly, so long as it is under the anæsthetic. There is nothing, so far as I understand the law, to say that that was not to be done."

Question 147 : " Then you say that it being the duty of Professor Starling to kill the dog, that according to the Act he is entitled to kill it by subjecting it first of all to a further operation and demonstration, and I suppose to that of any number of other lecturers into whose hands the dog may pass before it becomes finally unconscious ?"

Answer: " That would be physically impossible, because an animal cannot be kept under an anæsthetic so long."

" That is the only limit apparently? "

Answer: " That is the only limit so far as the law is concerned."

Question 150: " And you say you are entitled to put an end to the dog by opening it up for further experiment or further demonstration ? "

Answer by Dr. Bayliss: "Yes."

Question 151: " And that is putting an end to it ? "

Answer: " Yes."

And Professor Starling gave the following explanation in answer to Mr. Lawson Walton (Q. 455):

" Do you accept the view that Dr. Bayliss has given, that the handing over of a dog, to which one experiment has been applied, to another operator for a further experiment, is a mode of at once destroying it under the Act? "

Answer: " That is a legal point."

Question 457: " You think you were justified in doing it ? "

Answer: " Certainly, it was a question of using this dog which was to be killed to demonstrate something on it whilst it was being killed or to take a brand new dog and kill it for this very purpose; it was simply a question of taking one dog instead of two."

The sophistry of the last effort to clothe the breach of the Act and the prolonged vivisection of the Brown Dog in the garb of solicitude for the sacredness of animal life is distinctly humorous. The distinct illegality of the " legal point " could not even be altogether ignored by the *Lancet,* which in a leader, December 12th, 1903, wrote: " It may be contended that Dr. Starling and Mr. Bayliss committed a technical infringement of the Act under which they performed their experiments."* The inspector under the Act has given expression to some embarrassment over the treatment of the Brown Dog in his evidence before the Royal Commission of 1906. He stated that the handing over of an animal which has been

* NOTE.—The Editor of *The Medical Press and Circular,* on December 18th, 1907, referred to this subject in the following words:—" If anti-vivisectionists wish to labour the point of the demonstration being given on a dog which was under an anæsthetic used for a previous operation, there was no doubt, on the face of it, a technical breach of the Home Office regulations pertaining to that particular certificate."

operated on under Certificate B to a teacher who uses the same animal for a very severe operation under Certificate C *" is not a thing that one would desire to be done, and one would deprecate it "* (Q. 1,561, etc.). He further said that but for the trial he would not have known that the animal had been used for two sets of experiments, and that, if he had known, he would have told them that he thought they should not do it, and stopped them as far as he could. He would not have interfered from the point of view of the animal, but from the point of view of public feeling, he would have said that they had better not do it. (Q. 1,568.)

His confession that as far as he knows there may be other cases of a similar kind (Q. 1,565) serves to emphasise the general impression given of the complete inefficacy of the system of inspection.

The reader who has followed me so far may naturally ask why, if there was this undoubted contravention of the Act, the vivisectors were not punished in accordance with the requirements of the law, and why the trial ended in victory for them. The answer is evidently twofold. (1) Mr. Bayliss, being the plaintiff, was naturally not anxious to dwell on the point of this breach of law. Though it was incidentally elucidated in the course of the explanation given by the plaintiff and his friends of the existence of the clamping forceps in the fresh wound on the belly of the dog, every effort was naturally made to ignore it, and to turn all thought and attention to the " libel," *i.e.,* the comment made on the state of the dog during the half-hour when it was before the students. (2) The Public Authorities Act of 1898 renders illegal any proceedings against a vivisector, unless instituted before six months have passed after the alleged offence. The Cruelty to Animals Act of 1876 also makes any prosecution of a vivisector dependent on a special permission from the Home Secretary.

The most curious comment on the omission to kill the dog after the object of the two operations had been attained is certainly given in Professor Starling's own evidence before the Royal Commission on December 20th, 1906 :

(Q. 3,917, etc.) *Sir Mackenzie Chalmers* : " Whose duty is it to see that the animal is killed ? "—" *It is the duty of the experimenter.*"

" Your laboratory, I suppose, is the largest in London, and the most important ? "—" More work goes on there than in any other laboratory."

" Have you ever yourself—I am not speaking of your own opera-
tions, but the operations carried on in your laboratory—seen any careless-
ness or recklessness? "—" *No, never.*"

" Or any omission to kill the animal? "—" *No, none whatever.*"

Vivisectional confusion and inaccuracy of description of the *method*
of killing, previously referred to, is here supplemented by an extraordinary
discrepancy between words and action when the *duty* of killing is in
question.

The point next in importance to that of the legal aspect of the three
vivisections of the Brown Dog is perhaps that of its movements whilst in
the lecture-room. An operation board was produced in Court by Mr.
Bayliss as the identical one on which the dog had been fixed. It was
declared that the dog had been suffering from chorea following upon dis-
temper, and that the " violent and purposeful struggles " described by
the witnesses against the vivisectors were nothing but magnified twitches.
It cannot, however, but strike an unbiassed inquirer as highly significant
that, though the nature of these movements was differently interpreted
by the vivisectionists, their existence was not denied. On the contrary,
somewhat varied descriptions were given.

Thus, Mr. Bayliss himself could not swear that the animal might not
even have arched its back. He described the twitching as affecting " one
side of the body only, chiefly the muscles and the limbs " (Q. 208), and
Professor Starling located it in the " left side, arm, and leg."

Miss Eleanor Lowrie, a medical student, who gave evidence in corro-
boration of the vivisectors' statements, had, however, seen a *rather
forcible movement* of artificial respiration, and no twitching other than
" the movement of respiration, the hind and the forelegs." The same
witness, later in her evidence, said that she had seen no twitching and that
the animal was quite quiet. Mr. Douglas Hume, another student who
supported the vivisectors, described the twitching as " little and
irregular."

Mr. Scuffle had, not unnaturally, seen the twitching that Professor
Starling and Dr. Bayliss spoke about. " That is the only thing I saw,"
he added in illustration of the somewhat limited powers of observation
apparent to all who read the evidence of this faithful laboratory servant.

The vivisectors and their pupils declared that the dog was unconscious

and anæsthetised whilst it was experimented upon in the lecture-room, and that there was no foundation for the accusation that it was conscious and struggled forcibly. The value of a statement is obviously to be measured by the competence and freedom from professional bias in the one who makes it. It was urged with considerable force that the Swedish ladies were incompetent to judge whether the dog was suffering or not, as their sympathies were clearly with the dog rather than with the professor. Every opinion is, in a sense, bias. The constitution of men's minds makes them centres of gravitation for prejudices and opinions. There is no reason to assume theoretically that a man or woman naturally sympathetic to the sufferings of animals is not as reliable a witness as the one who is naturally indifferent, and who is blinded by routine and steeped in professional interests. *Attention* is the *sine qua non* of accurate interpretation of the evidence of the senses, and the mind, intently bent on observing whether an animal is suffering or not, will more likely carefully note the signs than a scientist who regards tenderness for animals as symptoms of hysteria, and scientific curiosity as the highest asset which a nation can possess. A typical instance of the unobservant attitude—towards the feelings of animals—fostered in the vivisectional laboratory, was afforded by Miss Janet Lane Clayton, a lady devoting herself to experimental physiology, who told the Court that she really did not know whether anything had been said concerning how a dog had been anæsthetised, because *she took the matter so absolutely for granted that she never asked.* (Q. 664.)

Commonsense tells us that the prejudice and practice of the vivisector divert his attention from the signs of pain and disqualify his judgment. We are assured that the Brown Dog was fully unconscious, and that it suffered no pain. What was the testimony offered? Which were the conditions and circumstances brought forward as evidence of its blessed state while for the third time its living body was offered on the altar of science ?

The charge that nothing had been said about the administration of an anæsthetic was admitted to be correct. But the vivisectors explained that the animal had been kept under anæsthesia by means of an electro-motor, which automatically pumped air laden with a mixture of alcohol, chloroform, and ether through a hole in the dog's trachea. The two chief witnesses for the defence had seen no motor pump for keeping up

the anæsthesia at work in the lecture-room, and it was admitted that the characteristic hissing sound (generally clearly heard when such an apparatus is at work) was absent during the whole course of the experiment, and that there was no smell of ether or chloroform perceptible either in close proximity to the dog or in the rest of the lecture-room. Dr. Bayliss, in his first day's evidence, gave the reason why the pump and apparatus for anæsthetising could not be seen nor heard by stating that the apparatus was in another room, and that the tube carrying the anæsthetic to the animal " came under the floor between the two rooms and was brought up through the table." He said that at the top of the table there was a tube visible—in the otherwise invisible apparatus—which was connected with a cannula in the dog's trachea.

Much pro-vivisectionistic energy was expended in efforts to prove to the jury that this remarkable tube was there. These efforts were successful—in Court. Let us, therefore, dutifully accept the judicial view and see to what conclusions it leads us. Can an automatic apparatus, placed in another room, produce the requisite attention and intelligent observation of the subject absolutely essential to the induction of reliable anæsthesia? No, such a method cannot but be highly unsatisfactory, more especially as Dr. Bayliss, when asked if he was near the dog all the time it was in the lecture-room, answered : " No, I was not in the proximity of the dog the whole time. I was by the lantern part of the time." (Q. 215.)

Mr. Sewell, the well-known canine surgeon, in giving evidence for the anti-vivisection side, stated that it would, in his opinion, be absolutely impossible to give an anæsthetic satisfactorily by means of such an apparatus, and that a special anæsthetist would always be necessary.

Many astonishing and disquieting statements in connection with anæsthesia were made by the vivisectors. Some absurd and conflicting utterances evidently escaped being run to earth through the haze of " scientific " authority. Thus, the dog was said to have had too strong a dose of morphia early in the afternoon, administered by Scuffle. The too strong dose of morphia was said to have been followed by such a strong dose of ether and chloroform that the animal was very nearly killed. When it was suggested that the application of such a strong dose of an anæsthetic, following upon the first dose, would kill the animal it was replied that there was a leakage in the tube, through which a certain

amount escaped. And yet, in spite of the "leakage," it was admitted that there was no smell of ether or chloroform in the room. The things admitted by the vivisectors are of infinitely greater importance than those which they denied. It is not libellous to say that a vivisector has experimented upon an animal without anæsthetics. Such experiments are performed every day, there are tens of thousands every year. The libel in this particular case was the accusation that Dr. Bayliss had committed a "statutory offence." For, according to the law, experiments before students under Certificate C must only be made under anæsthetics.

But some victories are proverbially worse than defeat. The fate of the Brown Dog now stands before the mental vision of thousands clearly silhouetted against the background of a law utterly inadequate to cope with scientific cruelty, and an administration which may well cause its bark to reverberate through our laboratories with the question : "Oh, Dogs of England, how long shall these things be?"

The unfoldment of the Brown Dog drama in the Court of the Lord Chief Justice was accompanied by the senseless applause for "science" and hilarious rowdyism of medical students who had assembled in the gallery. The trial lasted four days, and according to reports there was a queue thirty yards long outside the Law Courts. Five prominent vivisectors fought hard for the vindication of their rights. What was one dog compared with so much learning and so much anxiety to conform with the law! Mr. Rufus Isaacs led the prosecution. He towered far above the other legal luminaries in the force of his language, the pointedness of his satire, his scorn of the sentimental. He was an ideal exponent of the mind of the vivisector. He compelled the jury to see that it was ridiculous for two young women—and foreign women—to dare to come to this country and criticise the doings of British scientists. With the ingenuity and resourcefulness characteristic of his people he marshalled his arguments and skilfully played upon the chords of sex-prejudice and race-prejudice. Nothing was too small or too far-fetched to be utilised. He even suggested that the Swedish ladies sat there watching the sufferings of the dog, *enjoying* themselves.

The state of public agitation following upon the verdict must have been altogether unprecedented. Judging by the innumerable leaders and

letters which appeared in the Press, and which I have now studied, the public mind was brought to a state of high pressure. The organs of pro-vivisectionistic ideals seemed to gasp wearily: *Tant de bruit pour une omelette,* whilst that section of the Press, which is awake to the need of a higher standard of humanity, proclaimed the treatment of the Brown Dog to be a typical example of the cruelty of vivisection and the laxity of the law. The verdict was freely criticised in certain journals, and was commented upon as a miscarriage and a caricature of justice. The *Daily News* opened a subscription fund to defray the damages and the costs of the trial, and so strong was public feeling in favour of the dog that not less than £5,733 was collected within four months through this and other channels. Meanwhile, Dr. Bayliss had publicly announced that he was going to devote his £2,000 " to the furtherance of physiological research at University College."

Whilst I was in the midst of my researches into the history of the Brown Dog I was brought back to the actual controversy by a new " riot." On December 17th the papers contained lengthy accounts of a lecture given on the previous evening at the Caxton Hall by Miss Lind-af-Hageby, and entitled " Vivisection and Medical Students." The students had evidently pursued the author of their trouble, and by securing tickets under false pretences—as in the interests of peace and in the light of past experiences the presence of medical students had been deemed inadvisable —had managed to fill one part of the hall. The following extracts from some of the reports will show the nature of the " demonstration ":—

"THE MORNING LEADER."

The usual childish and disorderly scenes took place at the lecture given by Miss Lind-af-Hageby (the Brown Dog Champion) last night at the Caxton Hall on " Vivisection and Medical Students."

The disorder and uproar did not occur until towards the end of the lecture, partly because admission was by ticket only, and partly because the stairs were guarded by stalwarts from Battersea who had come up at their own request to defend the memory of their " Brown Dog." Later, however, a fairly large number of students managed to obtain tickets by some means, and others broke in by another entrance; so that, before the end, the meeting was broken up, and the usual pandemonium reigned.

The first interruption came when Miss Lind-af-Hageby mentioned the name of Professor Starling, who, it will be remembered, was connected with the vivisection trial in 1903. Loud cheers and cries of " Hear! hear! " came from the students who had now managed to group themselves in a little body at the back of the hall. . . .

"THE TIMES."

An attempt by medical students to organise a demonstration in connection with a lecture delivered last night at Caxton Hall by Miss Lind-af-Hageby on "Vivisection and Medical Students," was frustrated by the police. The cards of admission to the meeting bore the notice, "Medical students not admitted," and the staircase leading to the hall was lined with men who were said by the promoters of the meeting to have come from Battersea for the purpose of preventing any disturbance and of turning out undesirables. But, notwithstanding their presence, a large number of students managed to gain admittance, and towards the close of the meeting about a dozen others who had failed in their attempts to pass the guardians of the staircase broke into the hall through a door at the back of the platform, amid cheers and the waving of sticks. But beyond this and a few interruptions of the speaker there was very little disturbance. The conduct of the students in their recent attempts at protest against the "Brown Dog" inscription was severely criticised by the lecturer. Dealing first with the inscription itself, she said it was clear from the evidence of Professor Starling and others at the vivisection trial in 1903, that the inscription did not overstate the facts. As to the students, she asserted that they proceeded with violence of manner and vulgarity of speech, and insulted women at public meetings; and that their rowdyism had by far exceeded the boundaries of legitimate youthful hilarity and had descended into brutality. There were from time to time cries of "Withdraw" and "It is not true" from the students, and at one period some interruption was caused by one of them who had managed to get upon an adjoining roof and shouted his remarks through an open window. When the lecturer referred to the students as "young hooligans," one of their number rose to protest, but there were at once loud cries of "Turn him out," and he was obliged to resume his seat. After the lecture the Rev. John Baird (Aberdeen) was voted to the chair, and he invited an expression of opinion. Short speeches by members of the audience followed. Several medical students wished to speak, but only two of them succeeded in doing so. They declared they only wanted fair treatment, and that they had no desire to disobey the law. What they protested against was not the anti-vivisection movement, but an attack upon an institution which had done a great deal for education in London. While a lady was urging the nationalisation of hospitals in order to put an end to vivisection experiments, the students broke in at the back, and the meeting terminated soon after in disorder. Then the students sang "The Little Brown Dog" and "She's a Jolly Good Fellow," and finally got upon the platform, but they were not interfered with, and soon afterwards left the hall. A number of them marched in procession in the direction of Trafalgar-square, followed by police, but in Parliament-street they were met by a body of men from New Scotland-yard, who broke up the procession and turned them back. They then proceeded in small groups down Great George-street into the Park and attempted to hold a meeting on the Horse Guards' Parade, but were prevented by the police from doing so, and after a short time they dispersed.

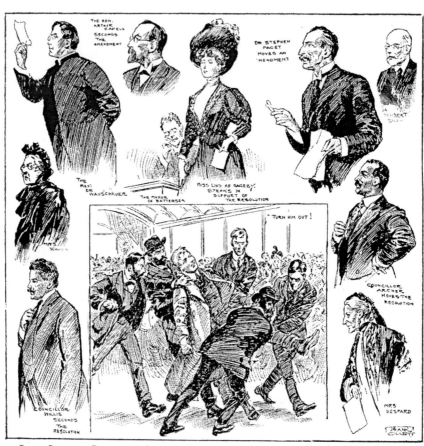

Brown Doggers at Battersea. A meeting in
support of the famous Monument and its
Troublesome Inscription. - - - - - -

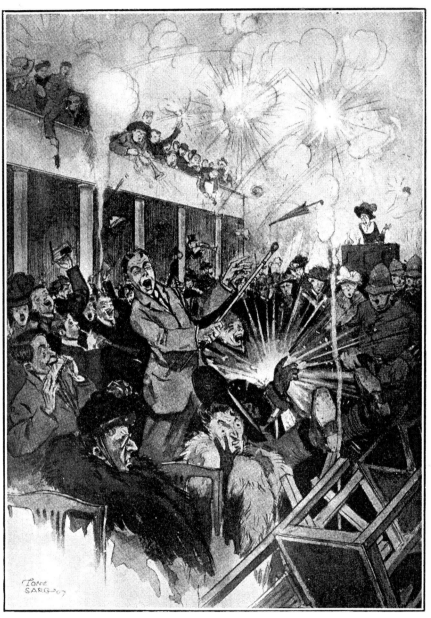

The lively Student at the present time seems to be dividing his favours between the Brown Dog and the Suffragette. - -

"THE DAILY NEWS."

Compared with their previous escapades last night's attempt of the " Brown Dog " students to upset the anti-vivisection meeting at Caxton Hall, Westminster, was decidedly unsatisfactory—from the students' point of view. A deeply-laid plot to rush the meeting was frustrated by the presence of several dozen stewards.

But these gentlemen notwithstanding, the students managed to create much uproar and disturbance. Admission to the lecture by Miss Lind-af-Hageby on "Vivisection and Medical Students," was strictly by ticket.

But about fifty students had procured cards of admission, and, as is their custom, occupied one of the bottom quarters of the hall. An attempt of four men to pass through on one ticket ignominiously failed. Three were returned to the street.

The lecture commenced in good order. " Recent riots of medical students had brought home to the public with unmistakable force," said Miss Hageby, " the demoralising effect of intimacy with vivisection. The morality of the medical students of London was a matter of the very gravest importance. Humanity of feeling and gentleness of manner should be their essential attributes. But the general public had a grave and immediate responsibility in the matter which could not be disregarded.

" These medical students who proceed with so much violence of manner and vulgarity of speech," declared the lecturer, " who insult women at public meetings, and whose rowdyism has by far exceeded the boundaries of legitimate youthful hilarity and descended into brutality, are at the present moment in the closest touch with the sick poor of the hospitals of London. Can we trust these 'hooligans' ? "

This was met with great disorder from the students. A reference to Mr. Paul Taylor was received with loud groans.

"DAILY NEWS" THANKED.

"I wish publicly to express the thanks of all anti-vivisectionists to *The Daily News* for the constant, lasting, and solid support which it gives day by day to our cause," said Miss Hageby. " The recent leading article in *The Daily News* is one on which we all should ponder."

Extracts were read from *The Daily News*, and then the lecturer proceeded to refer to the Brown Dog Memorial at Battersea. Having read the inscription, she asked, " Is this a lie ? " Loud cries of " Yes, yes," greeted the question, and from the back of the hall came the strains of the Little Brown Dog war song. It was a very weak attempt, however, and soon died away. From sundry noises and rumblings outside the hall, it was evident something unusual was in progress. An organised plot on the part of the students to rush the staircase had failed. After a hurried consultation, a move was made round to the side of the building. Here a large wall was scaled, and two of the more daring of the students climbed on to the glass roof of a portion of an adjoining hotel. With the aid of long sticks they were able to reach the windows of the lecture hall, and just as Miss Hageby was explaining the reasons of the anti-vivisectionist movement loud knocks upon the window panes were heard, accompanied by shouts of " Oh, dry up," and " Here's luck."

AN APOLOGY.

These remarks were greeted with loud cheers of encouragement by the students in the hall, and the noise continuing, police constables were sent to assist the young men from their place of 'vantage to the street again.

Miss Hageby having finished her lecture, it was decided to open a discussion ; Mr. John Baird, of Aberdeen, whose appointment was strongly objected to by the students, was made chairman. A student, giving his name as Lister, mounted the platform, and was understood to apologise for the recent riots and disturbances. At this point the students became somewhat rowdy, and the odour of the now familiar offensive chemical began to pervade the hall. A door burst open at the back of the platform, and about a dozen students rushed in amidst cheering, shouting, and the waving of hats and caps. This was part of the contingent which had failed to pass the stewards. They had gained entrance through an unlocked door.

The disorder continuing, the chairman closed the meeting. A little rough play in the hall by the students was followed by the singing of " For She's a Jolly Good Fellow "—this referring to Miss Hageby, and the students proceeded to march to Trafalgar-square by way of Caxton-street and Whitehall, accompanied by a fairly strong muster of police. Notice of their intention, however, had been sent to Scotland-yard, and by the time they reached the entrance of Whitehall they were met by a strong body of constables who, first having stopped them, turned them back. The students then proceeded down Great George-street and across the Horse Guards' Parade to the West-End, singing as they went, and so well guarded by police that there was no attempt at a demonstration.

The *Manchester Guardian* described the interruptions as " singularly devoid of humour," and the disturbers as " very poor specimens of the student class ; " and another leading provincial paper, in commenting on the behaviour of the students upon this occasion, expressed the hope that their teaching of medicine would be more successful than their teaching of good behaviour and common sense.

A correspondence in the Press on the legal aspect of the Brown Dog Memorial drew Mr. Stephen Paget into the controversy. His letter was preceded by one in the *Times* on December 24th, signed " F. R. C. S.," which described the inscription as " a downright lie; a gross, deliberate, carefully thought-out lie. . . . One of the most brutal and impudent lies that have ever been invented even by the anti-vivisection societies." Mr. Stephen Paget followed with an identity of sentiment and expression, which points to a close relationship between the two " F.R.C.S." " Was there ever quite such a lie ? " he wrote. " No lie so black has ever been allowed, I think, to stand in London. Here, surely, is ground for the interference of the Public Prosecutor. Why should a public falsehood

of the vilest kind be permitted to defile a public thoroughfare? There is a limit in a place like London to other indecent exhibitions, to obscene pictures, and to blasphemous oratory. The Battersea memorial is really not much better in its general tone and intention than these. If the Public Prosecutor cannot get the memorial removed, and the Battersea Borough Council will not, then University College must take steps to that end. Somehow or other the nuisance must be stopped. The public exhibition of a brutal lie is a public offence, and nobody knows better that the inscription is a lie than the hypocritical people who put it there." (*The Times,* December 30th, 1907.)

If mere strength of expression could have diffused the aggressive elements of the " indecent exhibition " in Battersea, the offending statue would certainly have had to evaporate before Mr. Paget's outraged feelings. But it remained in its place, acting in an ever-increasing degree as a stimulus to the activities of friends and foes. The Brown Dog took hold of the imagination of all London, he appeared in the Drury Lane pantomime, was flayed alive, and dismissed after a verdict of being in " shocking bad taste." Bad taste made him the hero of song, ballad, and sketch, and did not shun to thrust many a pointed dagger at science and the dignity of its youthful votaries, as the following lines will show :—

THE BROWN DOG OF BATTERSEA.*

A CYNICAL BALLAD.

Oh, the Brown Dog of Battersea has eaten Science up,
 As he sits there, made a martyr for the fools ;
Though she thought him dead and done for, predestined from a pup,
 To be eaten up like Herod in her schools.

 Chorus : Poor Old Dog.

For she saw uncommon promise in his tautophonic tongue,
 When he used the cynic habit of the tyke ;
So she entered him at college, and attended to each lung,
 While her needles went dainty as you like.

 Chorus : Poor Old Dog.

He licked the hand that held him while they drew the binding strap ;
 Tender beast !—the microbes liked him too ;
We all took kindly to him when he wagg'd his tail, poor chap !
 And every week his brown skin skinnier grew.

 Chorus : Poor Old Dog.

While he lived he lived for Science, and died an altered beast.
 'Tis this stony resurrection hurts his friends ;
And the motto, as you read it, is not likely, not the least,
 To help Science, or small doggies, to their ends.
 Chorus : Poor Old Dog.

Oh, the Brown Dog of Battersea has eaten Science up,
 As he sits there, made a martyr for the town ;
But though nine tailors, ninety beaks, and John B——ns guard the pup,
 We mean to have the Brown Brute down !
 Chorus : Poor Old Dog.

 A POET-NOT-LAUREATE.

 * All rights reserved (but may be sung at medical schools and colleges).
From the *Daily Chronicle*, December 21st, 1907.

Not even the lamentations of the *British Medical Journal* could stay
the mighty tide of anti-vivisection feeling which the Brown Dog had
created. "The dog is," wrote the *Journal* on January 4th, "as anyone
might have foreseen, being used as an advertisement of anti-vivisectionism ;
and this makes it the more deplorable that any medical students should
have given such a chance to the enemies of science."

The enemies of the Brown Dog were jubilant when on January 7th the
Press announced that the Chief Commissioner of Police had written to
the Battersea Borough Council calling upon that body to pay £700 a
year for the protection of the memorial, or to have it removed. The letter
drew attention to the seriousness of the situation and to the fact that the
Brown Dog was guarded night and day by two constables, which necessi-
tated taking six men daily from their ordinary duties. In thus attempt-
ing to bring about the removal of the memorial by misapplying economics
the Chief Commissioner of Police must have acted under the unfortunate
inspiration which had previously been responsible for Sir Philip Magnus'
misguided views of police duties.

The Mayor of Battersea expressed indignation in an interview at the
extraordinary proposal of the Chief of Police.

"We have been simply amazed at the Commissioner's letter," said
the Mayor to a *Daily News* representative yesterday, "and some members
of the Council will endeavour to find out by whom he has been moved in
the matter. You might as well ask a neighbourhood, where burglaries are
frequent, to pay the expenses of the detectives who scour the country to

recover the stolen property and apprehend the thieves. We already pay in Battersea close on £22,000 per year in police rates, and we contend that it is the duty of the police to preserve order. If a set of hooligans from other parts of London, most of them non-ratepayers, come and disturb the peace here, why should we have to pay for their misdeeds? I have every sympathy with the police. They have a difficult task and they perform it well, but as we do not make the riots, why ask us to pay for them?

" No," he continued, " I do not think for a moment that the Council will consent to remove either the fountain or the inscription. Neither will we pay for extra police any more than the omnibus companies pay for the posse of police protecting their garages during the present strike." (*Daily News,* January 8th, 1908.)

Mr. Runeckles' motion to remove the inscription, and a letter from the Commissioner of Police, were introduced at the meeting of the Battersea Borough Council on January 9th, but the debate was adjourned until the next meeting of the council. Meanwhile, preparations were made for a mass meeting to be held in the Battersea Town Hall, on January 13th, at which the Mayor of Battersea should take the chair, supported by several councillors, and Miss Lind-af-Hageby speak on " Is the Inscription a Lie ? "

On the evening of the great meeting Battersea seemed to be thoroughly aroused to defend its memorial on anti-vivisection principles. The talk in the streets was all about *the* dog, and as I stood watching the stream of working men that filed into the hall long before the appointed time I realised the full moral strength of the anti-vivisection movement which can thus fire thousands of hearts into wholehearted denunciation of the fate of an unknown dog. " Mad sentimentality," " hysteria," and " mental degeneration," says the narrow-hearted vivisector, as he listens to the clamour for mercy and liberty for the victims pinioned to his operation board. But the common humanity of the twentieth century seems to be advancing beyond his vision.

When the meeting began the hall was filled to overflowing with an enthusiastic audience, whilst hundreds of people were unable to gain admission. In view of previous experience some 400 men from Battersea had volunteered their services as stewards to ensure an undisturbed meeting, and lined every approach to the hall. The air seemed to be charged

with the special electricity of stirring questions. The Mayor of Battersea
(Alderman F. W. Worthy) opened the meeting by declaring that the in-
scription was truthful, and that Battersea ratepayers had no intention of
paying £700 for police protection of the memorial. The resolution of the
evening was moved by Councillor J. R. Archer, and ran as follows :—

" That this meeting expresses its conviction that the inscription on
the Brown Dog Memorial is a veracious reference to ascertained facts,
and understates rather than overstates the fate of the dog, and that neither
it nor the statue should be removed from their present position ; further,
this meeting expresses its opinion that vivisection in all forms is a cruel
and demoralising practice and a stain upon the civilisation of the world,
more especially in the encouragement and support of vivisectional demon-
strations before students."

Councillor Willis seconded the resolution, and pointed out that there
were men, women, and children in Battersea who, believing firmly that
the memorial was justified, would offer their services as voluntary pro-
tectors, should the Commissioner of Police forget his duties to the British
public in general and to Battersea in particular. He challenged Univer-
sity College to bring a libel action if they could prove the inscription to
be a lie.

The little Brown Dog's strange grip on public imagination was shown
with extraordinary force when the story of its fate was again told in
measured and incisive language by the woman who has been termed " The
Brown Dog's Champion." " A tremendous ovation was accorded to Miss
Lind-af-Hageby on rising to support the resolution," wrote one of the
morning papers the following day, and another : " When she commenced
to speak and denied that the inscription on the monument was a lie, there
were cries of ' It is a lie.' Nearly the whole of the audience sprang to
their feet, and hundreds mounted chairs. Reporters sprang upon the
table, at which they had previously been quietly writing. For a time
the scene was very animated, the protestors continued to protest, and
there were to be heard from all parts of the hall loud demands to turn
the medical students out. About two dozen stewards rushed to where
three young fellows stood gesticulating, took them by the shoulders and
forcibly ejected them into the street." (*Daily Chronicle,* January 14th,
1908.)

But throughout the meeting there was a force at work which the vivid reports of the following morning did not portray. It was the breaking down of indifference and prejudice ; it was the triumph of truth.

Miss Lind-af-Hageby had defended the inscription, clause by clause, and justified its existence to the satisfaction of Battersea ; Mrs. Despard had appealed to the higher instincts which will make vivisection a moral impossibility, when Mr. Stephen Paget asked permission to address the meeting. As the chief upholder of the cry of " It is a lie " he was allowed to speak from the platform and to place his reasons for the feverish opposition to the memorial before the great meeting. He moved an amendment : " That the inscription gives a false account and, therefore, should be removed," and proceeded to tell the meeting that the experimental process to which the Brown Dog had been subjected had been absolutely painless. He went to the utmost limit of vivisectional argument by saying : " Everybody knows the dog was not touched." He made lavish use of the assertions and controversial style which he had previously used in the *Times*. He did not make converts. Battersea wholeheartedly rejected him and his amendment. He was followed by the Hon. A. Capell, who, in a violent speech, denounced anti-vivisection, and called Miss Lind-af-Hageby " a discredited witness," after which the meeting refused to hear him. After several vain attempts to continue his speech, during which the protests of the Battersea men filled the hall with the roar of indignant throats, Mr. Paget's supporter hastily retired, it is hoped to learn manners before attempting another public appearance. The resolution was passed amid great enthusiasm.

I have attended many meetings, but few which have offered better opportunities for study of the psychological elements of human strife. Ancient battlefields are making way for modern platforms. But now, as of old, the battle brings out the strength and the grit of the superior. Now, as of old, it exposes the weakness and the cowardice of the inferior.

On January 22nd the Battersea Borough Council decided to retain the inscription and the memorial by twenty-nine votes to five. Mr. Runeckles' resolution to remove the inscription was lost, and Councillor Willis moved the following amendment, which was carried :—

" *That the inscription on the memorial being founded on ascertained facts, the Council decline to sanction the proposal to remove it. That the Commissioner of Police be informed that the care and protection of*

public monuments is a matter for the police, and any expense occasioned thereby should be defrayed out of the police rate to which the Borough contributes so largely. Also, that the Council consider more strenuous efforts should be made to suppress any renewal of the organised ruffianism which has recently taken place in the Metropolis in connection with the memorial."

Mr. Willis said that in his judgment there was no reason at present for the removal of the inscription. There would come a time when it might be right to remove it—when the abolition of the present vivisection system would make the inscription unnecessary. The Police Commissioner's letter was a shocking confession of incompetence. If the police were in earnest there could not be the least difficulty in sternly suppressing any attempt to remove the inscription. If violence were used to the memorial such a dastardly act would rouse a feeling of intense indignation. A larger and finer memorial would be erected with a more stinging inscription. He asked the Council not to let itself be intimidated by a letter which had no substantial foundation. (Times, January 23rd.)

Mr. Runeckles presented a petition to the Council signed by a thousand students of the London University, in which the ingenuity displayed betrayed that employment of the last resource which is always a sign of defeat. The petitioners wrote :—

" We would respectfully draw your attention to the fact that in our opinion the question you have to decide is not whether vivisection is right or wrong, but whether it is not highly unjust to single out one college, and attack it for doing what the large majority of universities are doing.

" We therefore petition you to remove the words ' University College ' from the inscription because they hold up one institution to be specially condemnable and are therefore unjust to that institution."

The petition went so far as to state that some of the signatories were " indeed strong anti-vivisectionists," and even quoted Miss Lind-af-Hageby in support of their desire to have the name of University College removed. The extraordinary want of logic in the authorship of the petition makes the request for the removal of the name of University College somewhat humorous. The confused and temperate language of the petition was very different from the forceful denunciations of the " lie " and the " libel " of a few weeks previously. The petition did not succeed in causing one letter of the inscription to be altered, nor did the

subsequent announcement that the students of the University of London were planning a permanent Brown Dog League for the purpose of organising persistent attacks on the Brown Dog memorial.

On February 6th Sir Philip Magnus brought the Brown Dog question before the House of Commons by asking the Home Secretary whether his attention had been drawn " to the special expense of police protection of a public monument at Battersea that bears a controversial inscription," and whether he would " consider the advisability of introducing legislation with a view to prevent the erection in public places of monuments bearing inscriptions calculated to offend a large section of the people."

This seemed an extremely lame effort after all the declarations of probable Parliamentary interference.

Mr. Gladstone answered that the total amount of extra police duty which the protection of the Brown Dog monument had necessitated in the Borough of Battersea alone had been equivalent to the special services for one day of no fewer than 27 inspectors, 55 sergeants, and 1,083 constables. Six constables were daily employed in this manner. In addition to this, large numbers of police had on several occasions to be specially employed in other parts of London to cope with disturbances arising out of the same matter. He did not think that there was ground for introducing legislation.

Sir Philip Magnus asked whether the Home Office was able to take some steps to prevent this heavy expenditure from falling on the rate-payers, and whether the Right Hon. gentleman was aware that a large body of students were prepared to remove this monument, if they could do so without the interference of the police, without expense to the rate-payers.

Mr. Gladstone answered : " I am afraid I have no suggestion to make unless the Borough of Battersea themselves contribute to the protection of the monument."

Mr. Donald Smeaton : " Is the Right Hon. gentleman aware that the exact statement on the inscription is admitted ? "

The Speaker : " The hon. member is raising a very debatable question."

Thus ended the attempt to call the powers of the House of Commons to the aid of the enemies of the Brown Dog. All the weapons which

confidently have been held up as efficient to destroy it have been tried and have failed. The threatened libel action has vanished, '' ventilation of the true facts '' has sadly failed the vivisectors—as was shown by the meeting on January 13th—and has only served to strengthen public opinion and to reinvigorate anti-vivisection principles. Mr. Runeckles' efforts to induce Battersea to cast out its dog have ended in greater determination on the part of the people to retain it. Everything has been tried—from brute force and abusive language to gentle prayer and diplomatic self-restraint. And yet the dog is victorious. He is playing the part which every known martyr—consciously or unconsciously—has enacted: that of drawing humanity above the limits of its ordinary moral perception.

THERE'S LIFE IN THE BROWN DOG YET.

" Them 'thusiastic student chaps
 'Ad best let dead dogs be,
Or they may wake a Frankinstein,
 Wot ain't quite good to see.

" I didn't ask no Monument
 To speak for such as I.
I only begged them Science blokes
 To let the Brown Dog die.

" A dog's a dog, an' sure a dog
 Ain't worth much stir or strife.
It's odd the Great Creator thought
 'Im worth the breath o' life.

" If the Brown Dog 'ad power to trace
 Upon a stone 'is name,
'E'd carve in crimson drops o' blood
 The nom de plum o' '*Shame*.'

" Not all the caterwauls o' night,
 No Suffragist's shrill clack
Can penetrate the silent sod,
 To call the Brown Dog back.

" It's often said that this 'ere world
 Is all we've got to get,
That we 'ere creatures ain't a soul,
 Which pulls agin the bit.

" We sees a rum old few sometimes
 Whose modes we won't discuss,
An' if the likes o' *them* as *spooks*,
 Why not the likes o' *us* ?

" 'Twould be a contradiction plain
 O' all that's just or kind,
If those 'ere coves goes risin' up,
 An' we gets left behind !

" Maybe, above the Milky Way,
 Beyond the reach o' pain,
Where vivisection fiends ain't loose,
 The Brown Dog lives again."

 BEATRICE MOLYNEUX.

From " JOHN BULL," *January 18th, 1908.*

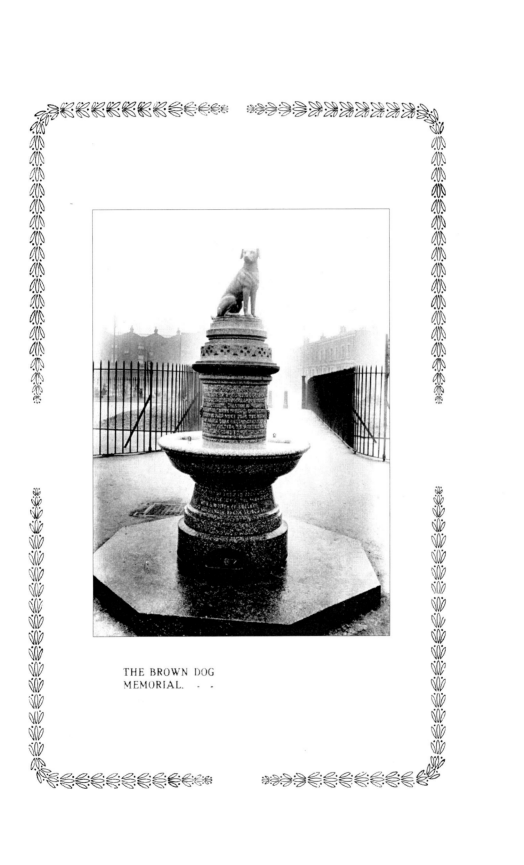

THE BROWN DOG
MEMORIAL. - -

Lightning Source UK Ltd.
Milton Keynes UK
UKOW031121210513

211010UK00004BB/7/P